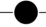

LYONEL FEININGER

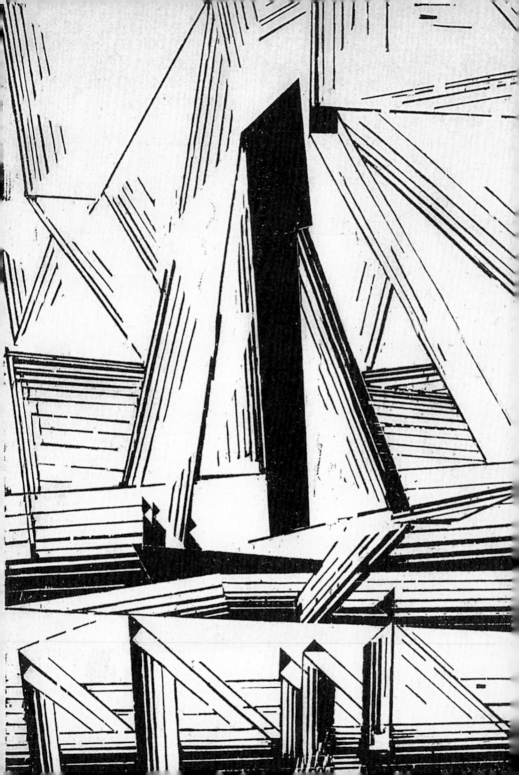

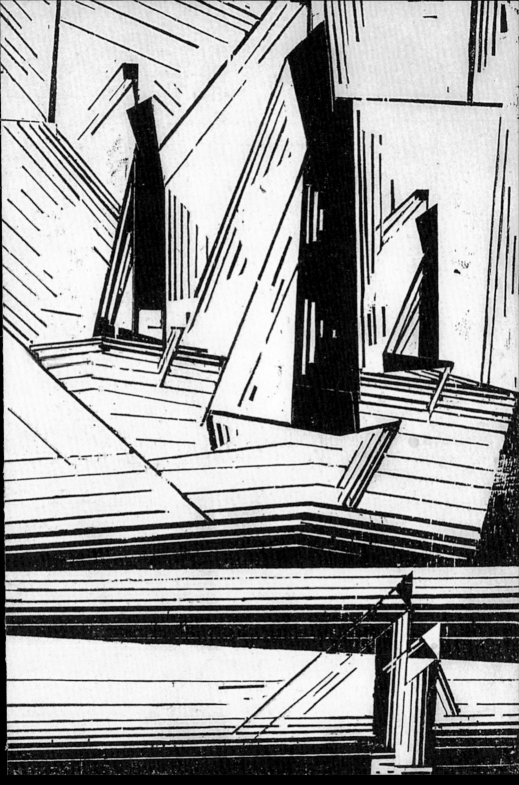

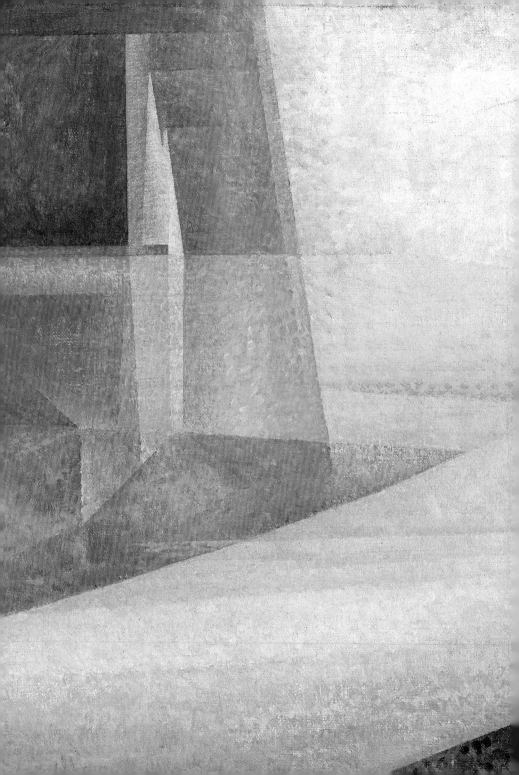

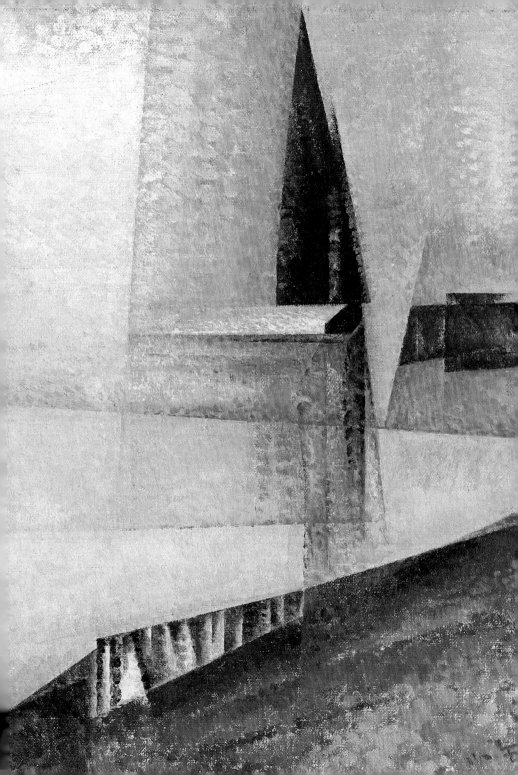

LYONEL
FEININGER

BY
Ulrich Luckhardt

HIRMER

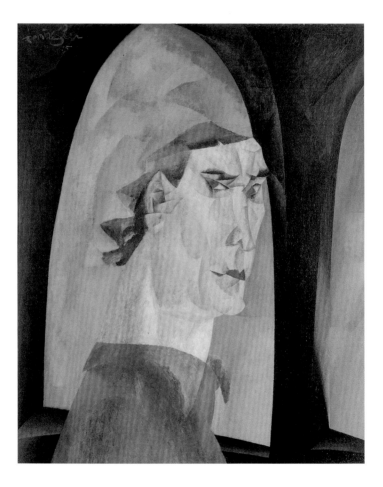

LYONEL FEININGER
Self-portrait, 1915, oil on canvas,
Sarah Campbell Blaffer Foundation, Houston

CONTENTS

PAGE 10
'That which is seen has to be inwardly
transformed and crystallized'
Ulrich Luckhardt

PAGE 46
Biography

PAGE 60
Archive
Finds, Letters, Documents

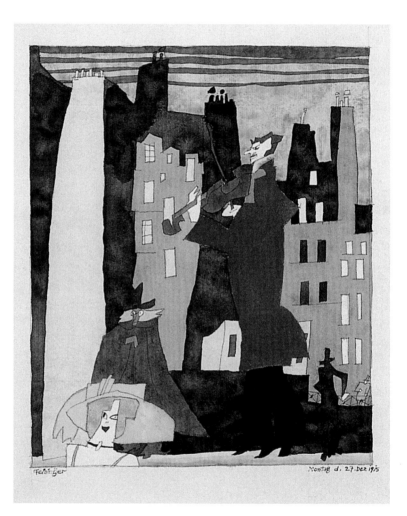

1 *The Red Violinist*, 1915, ink, watercolour on paper, private collection

'THAT WHICH IS SEEN HAS TO BE INWARDLY TRANSFORMED AND CRYSTALLIZED'

Ulrich Luckhardt

'In the vision, in the style of Lyonel Feininger, the disparity of the concepts of travesty and fugue is abolished in the most curious manner, and as these seemingly incompatible concepts define the tension of his work, their unfathomable congruence emerges as its ultimate depth.'[1] It was with this fitting statement that the art writer Willi Wolfradt began his extensive essay about Lyonel Feininger's artistic work, which was printed in the magazine *Der Cicerone* in 1924 and published unchanged that same year with the addition of 32 black-and-white illustrations and one colour plate as the 47th volume in the series *Junge Kunst* by the Klinkhardt und Biermann Verlag. It was the first monographic book ever written about the artist. By using the terms 'travesty' and 'disparity' as well as 'vision' and 'fugue' Wolfradt immediately brings to readers' minds that which characterizes Feininger's art and makes it unique to this day. The path to get there – for Wolfradt the path as far as 1924 – encompassed a multi-faceted body of works that continued to develop until the artist's death in 1956.

'I'M BARELY AN ARTIST. AT LEAST NEVER IN THE CLOWN JOKES THAT THE WORLD KNOWS FROM ME.'[2]

The year 1906 marked the high point and crisis of Feininger's early career. His humorous and later political caricatures were published by various magazines in Germany from 1890 onwards. Printed in *Ulk, Lustige Blätter,*

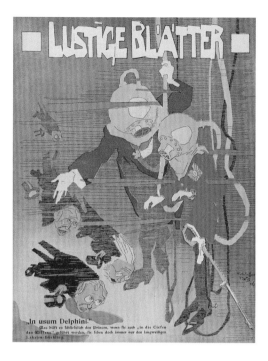

„In usum Delphini."

(Was hilft es fchlieflich den Prinzen, wenn fie auch „in die Ciefen des Willens" geführt werden, fie leben doch immer nur den langweiligen Eskaten-Büchling.

2 *In usum Delphini,* from: *Lustige Blätter, XXI*, 1906, no. 50, p. 20

Das Narrenschiff, Berliner Illustrirte Zeitung, Der liebe Augustin and *Das Schnauferl* these drawings soon made Feininger one of the most popular caricaturists in the Berlin of the imperial period. Until 1910 he supplied the magazines with his frequently odd illustrations in which after 1900 he developed his own drawing style that immediately caught readers' eyes. The subject matter in each case was predominantly set by the editorial departments. The artist was therefore a workman whose creativity was reduced to visualizing the ideas of others. What had liberated him from the constraints of the art academy in his early days as a caricaturist and had played a decisive role in leading him to his own free, artistic path was now turned into a barrier to his own development by the magazines and their editorial departments. It was only in the colour reproductions of the caricatures that Feininger was given free rein; it was particularly for his works for *Lustige Blätter* that he took advantage of the new techniques in printing. In addition to his clear pen drawings, often structured by geometric grids, combined with completely new basic colours, he developed a

colourfulness that had never before existed in the magazines of those years. Feininger contrasted colourful areas with colour gradients that he achieved by printing the individual colours on top of each other. He was particularly masterly at this in the caricatures he produced between 1905 and 1908, exhibiting a skill level unique in the German Empire at the time. Thanks to his contract with the Chicago Sunday Tribune for two comic strips, *The Kin-der-Kids* and *Wee Willie Winkie's World*, Feininger achieved financial independence – 'liberation'.[3] This made it possible for him to largely give up his work drawing for the magazines in Berlin and following his separation from his wife move to Paris with his new partner Julia Berg in summer 1906. In Julia, who was studying at the Grossherzogliche Sächsische Kunstschule in Weimar, he found someone who supported him in his striving for free artistic development.

After the publishing company in Chicago cancelled the lucrative contract – because of his divorce proceedings Feininger was unable to come to Chicago as had been agreed – Feininger was forced to resume his work

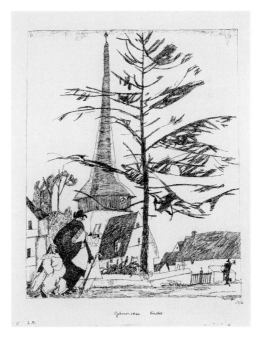

3 *Gelmeroda Church*, 1910, ink on paper, private collection

drawing for some of the magazines in Berlin while living in Paris. His drawings, which he sent to the German capital from France, unsettled the publisher of *Lustige Blätter* Otto Eysler. He wrote back saying that he, Feininger, had developed 'a certain grotesque and highly extreme tone during his stay in Paris [...] that was no longer comprehensible to the German readership'.[4]

In Paris Feininger was given the opportunity to publish his drawings, which had by now increasingly set themselves apart from his German caricatures and had become pictorial compositions in their own right, in the newly established magazine *Le Témoin*, for which Juan Gris and Félix Vallotton – to name but two – were also working. Now, in Paris in 1907/08, Feininger abandoned his long-standing career as a caricaturist and became an independent artist who would only pursue his own development from hereon in. Looking back, he wrote to Eysler: 'I'm far away from minimizing the very important developmental years that I went through as a "draughtsman for comic papers" – quite the contrary! They were my only disciplining element.'[5]

'GROTESQUE THOUGHT, TO BE CONDEMNED TO CREATE IN ETERNAL TRAVESTY'[6]

After several conventional city views of Paris Feininger started, in August 1907, to capture the landscape on the island of Rügen in small-format oil sketches. He told Julia: 'It's not for nothing that you start at age 36 painting like a cheery old man, painting with a locomotive-like passion for eight to ten hours every day.'[7] A short while later he produced his first painting on canvas in Paris: *The White Man* (4). The composition was identical to the first of his drawings printed in *Le Témoin*. The paintings that now followed – which matched the unusual colourfulness of the caricatures published concurrently in Germany – were also developments of drawings. Feininger had now found his artistic medium; all that was left for him to do was discover new motifs.

He had read the great novels of French literature, the works of Victor Hugo, Honoré de Balzac and Eugène Sue, early on. After his return from Paris in autumn 1908 Feininger returned to this body of literature, reading it once again, in French of course. His pictorial world changed imme-

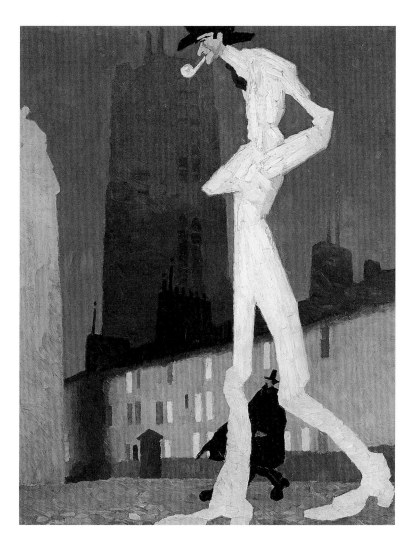

4 *The White Man*, 1907, oil on canvas,
Museo Thyssen-Bornemisza, Madrid,
on permanent loan from the
Carmen Thyssen-Bornemisza collection

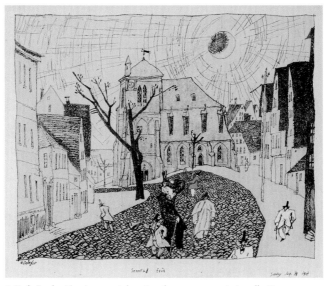

5 *Early Sunday Morning*, 1910, ink, watercolour on paper, private collection

diately. The drawings and paintings he now produced featured bustling activity against a Parisian backdrop in which workers and mothers, shady characters and prostitutes populated the streets alongside clerics, children, individuals in grotesque masks, and small and fat as well as excessively tall types. It cannot be gleaned what brought all of these very different people together or what caused all of them to be out on the streets. The individual characters have their counterparts in literature, but not performing the activities they can be seen acting out in Feininger's pictorial world. It is an unreal world of masquerade in which Willi Wolfradt recognized a travesty of reality.

During his time in Paris Feininger did not merely draw the city's architecture in sketches; in just seconds he also captured the outlines of the figures populating the streets, transferring them to paper. Feininger drew thousands of these 'nature notes' (pp. 66/67). He used them as 'capital' until his death, a repertoire from which he regularly drew inspiration. There are colourful sketches of many of the figures in the masquerade compositions that Feininger compiled into pictures like collages.

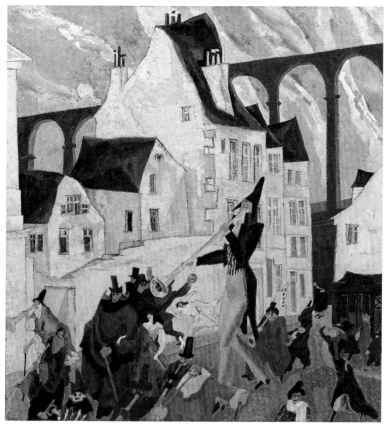

6 *Carnival in Arcueil*, 1911, oil on canvas, The Art Institute of Chicago

7 *Melancholy*, 1911,
ink on paper, private collection

'I HAVE ONLY LEARNED OVER THE PAST FIVE YEARS WHAT ART COULD BE FOR ME'[8]

Paris would be of crucial significance for Lyonel Feininger again, namely in spring 1911. He received an invitation to participate in the exhibition of the Société des Artistes Indépendants. This was the first time he showed six of his paintings in public, including his *Great Revolution* (8). Even though his works were paid almost no attention, the encounter Feininger had with Cubism – a movement that had developed in France in the preceding years – was a radical insight for the artist. His comment to Julia

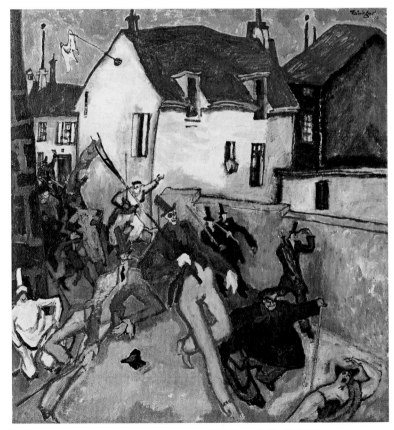

8 *Great Revolution*, 1910, oil on canvas, The Museum of Modern Art, New York

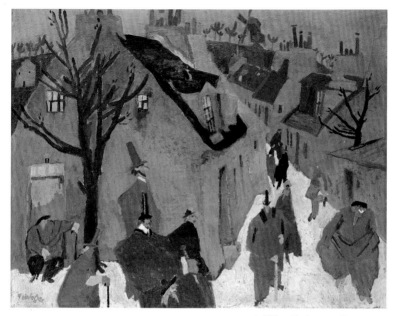

9 *Village, Dusk*, 1909, oil on canvas,
Staatliche Museen zu Berlin, Nationalgalerie

four years earlier, in the context of his first, post-Impressionist paintings,
that 'that which was seen' had to be 'inwardly transformed and crystal-
lized',[9] now took on a meaning for Feininger that had not hitherto existed.
Once again it was nature-notes, this time ones that he had created in
Heringsdorf on Usedom, that served as the basis for new pictorial compo-
sitions. Feininger maintained the sketches' structure; in *Angler with Blue
Fish II* (10) he kept the beach with the figures in the foreground, the water
in the middle and the horizon in the background. The figures in archaic
dress were also taken from the repertoire of the masquerade pictures.
Everything had now become angular, however, cemented in spaces that
joined together. The parallel vertical stripes in the middle of the picture
depict the perpetual motion of the waves.
'His Cubism, insofar as this fashionable term is even applicable [...],' Willi
Wolfradt wrote, 'is by no means an academic reduction of abstraction, but
rather a transfer of the familiar, taken artistically to the point of triviality,

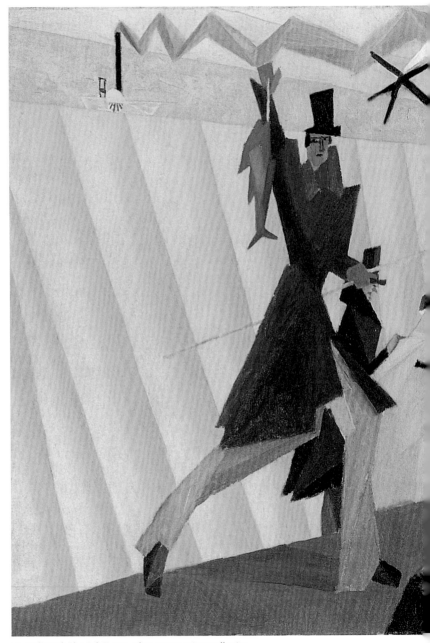

10 *Angler with Blue Fish II*, 1912, oil on canvas, private collection

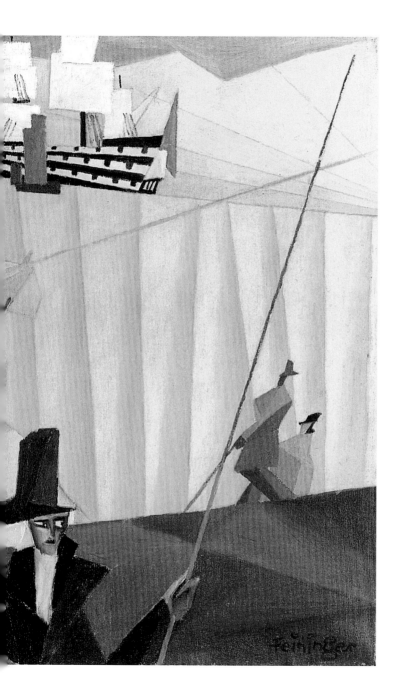

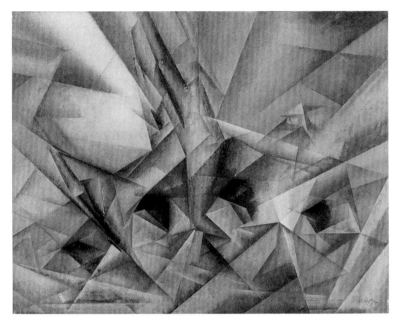

11 *Bridge V,* 1919, oil on canvas, Philadelphia Museum of Art

into a sphere of dreams and inscrutability.'[10] Travesty was replaced by fugue.

What still came across as static and stiff in 1912, in works such as *Angler with Blue Fish II*, was already changing the following year. Feininger began breaking up the forms in a faceted manner and overlaying them. The elements that still appeared two-dimensional to viewers of the works of the previous year now made way to a penetration of the pictorial surface by means of colourfully and finely nuanced forms to produce a pictorial space hinting at three-dimensionality. Unlike the French Cubists Feininger was not concerned with an object simultaneously presenting different views; instead he was focused on the spatial depth from which the motif emerged. Over the following years he kept developing this unique style; he found a monumentality in the crystalline overlays of the areas which in-flated objects in the images, such as the small church in Gelmeroda or the bridge across the Ilm in Weimar, that were in reality inconspicuous. The splintering of the motif went hand-in-hand with a harmonization of the

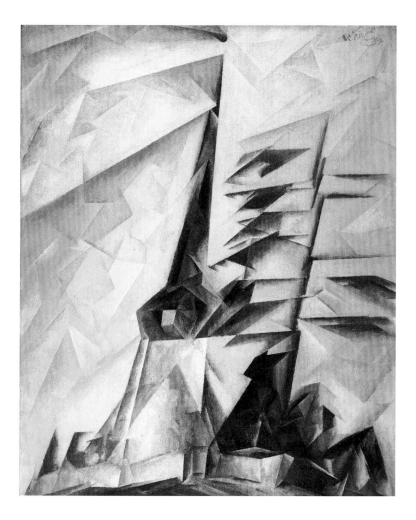

12 *Gelmeroda II*, 1913, oil on canvas,
private collection, courtesy of Neue Galerie, New York

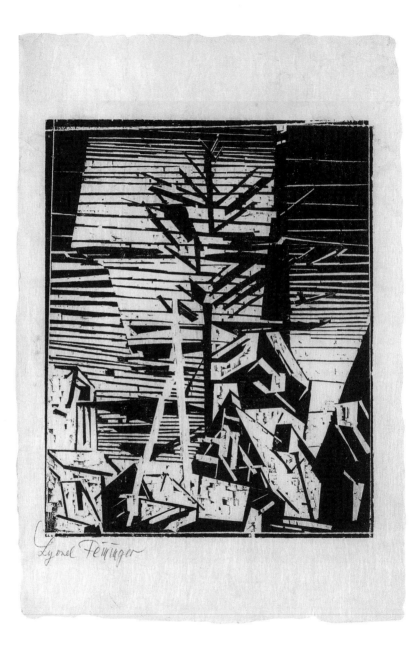

13 *Gelmeroda with Fir Tree,* 1918, woodcut on paper,
Kunstsammlungen Chemnitz, Loebermann Collection

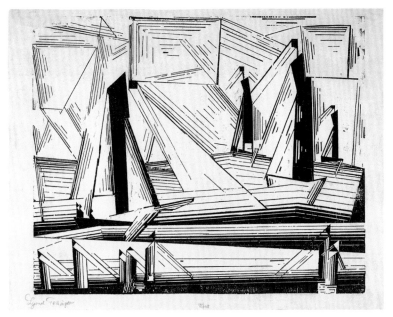

14 *Fishing Boats*, 1921, woodcut on paper,
Kunstsammlungen Chemnitz, Loebermann Collection

coloration. With this completely new perspective, especially on architecture, Feininger managed to achieve increasing recognition as a painter, starting in 1917, when he had his first major solo exhibition in the gallery Der Sturm in Berlin.

However, when the United States entered World War I in 1917, Feininger's situation changed. As an American citizen he became an enemy alien in Germany, and regularly had to report to the police in Zehlendorf. Materials for painters also became scarce during the war and to the extent that they were available they were of lesser quality. It was during this period that Feininger discovered woodcuts as a new artistic medium – probably at the suggestion of his friend Karl Schmidt-Rottluff. In 1918 alone he produced at least 117 sheets, the majority of his woodcut works, which, along with his painted architectural compositions, prompted Walter Gropius in 1919 to hire Feininger as a teacher for the Bauhaus school that he had founded in Weimar. Once there Feininger took on the direction of the printing shop and it was also the first time he had a professional studio for

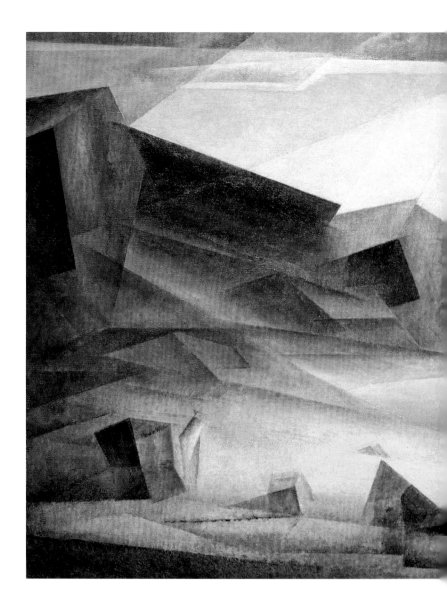

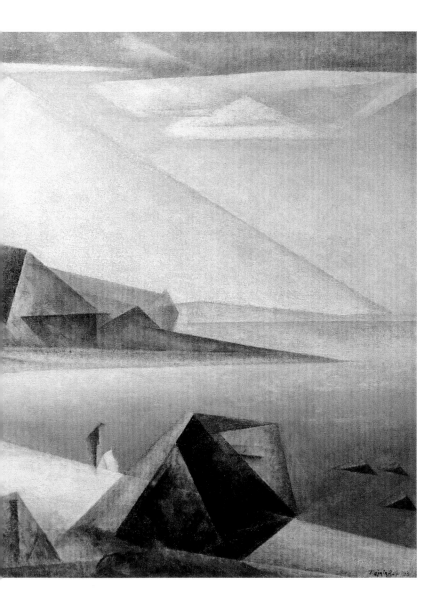

15 *The High Shore*, 1923, oil on canvas, Albertina, Vienna,
on permanent loan from the Forberg Collection

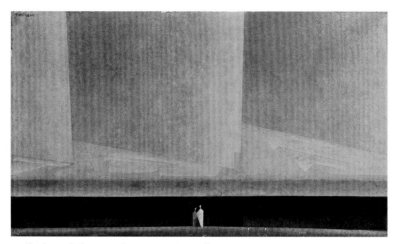

16 *Clouds over the Sea,* 1923, oil on canvas, private collection

painting at his disposal. Feininger, the former caricaturist, was at the height of his success as a visual artist. Museums and private collectors both began taking an interest in his art.

'I HAVE SO MANY IMPRESSIONS OF THE BEACH, OF THE SEA, THE SKY AND THE PEOPLE I ENCOUNTER'[11]

A trip during the summer of 1922, which he undertook together with Gropius and Vasily Kandinsky to the Bay of Lübeck, resulted in new impressions for him. Up until this point the focus of his artistic interest had been on the architecture of Thuringian villages and their churches; now however, he set his sights on the sea.

A clarification took place in the clearly structured space of the beach, water and horizon with clouds, which in 1912 had still been divided up fitfully into individual areas. Feininger gave order to the pictorial space that revealed itself to the viewer like a stage set. The human figures no longer staged themselves; instead, they now blended with the pictorial composition and became indicators of scale for the perspective. The splintering of the pictorial space gave way to a harmonization where the

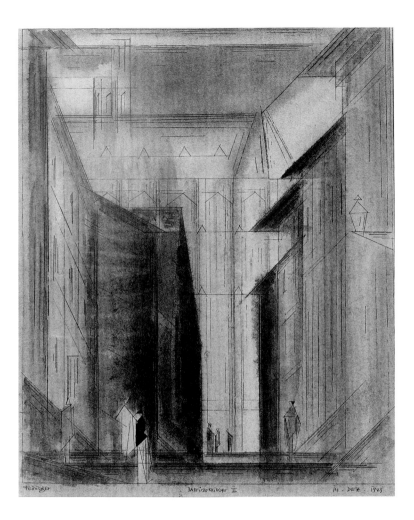

17 *Franciscan Church II*, 1923,
ink, watercolour on paper,
Angermuseum Erfurt

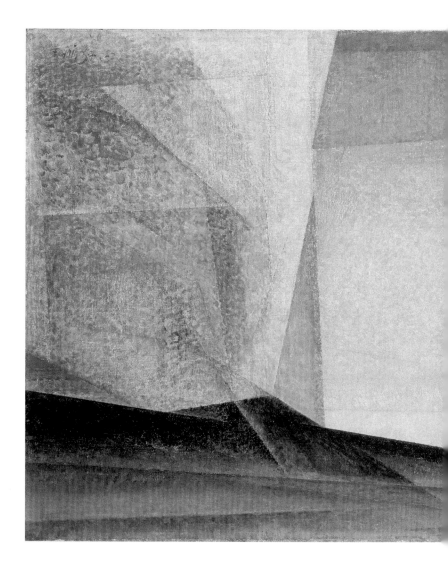

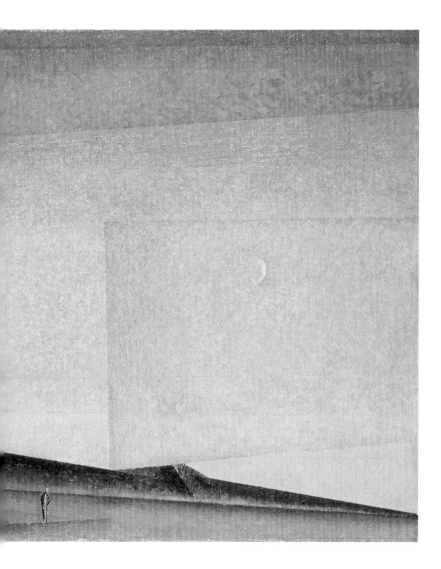

18 *Dune, Evening,* 1927, oil on canvas,
LWL-Museum für Kunst und Kultur, Münster

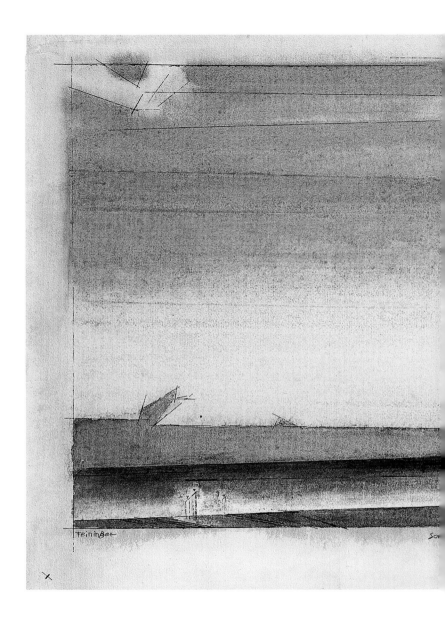

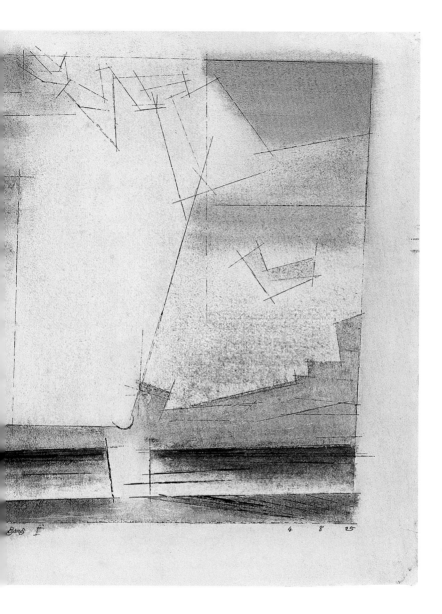

19 *Sunset*, 1924, ink,
watercolour on paper,
private collection

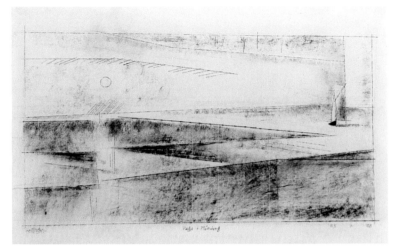

20 *Mouth of the Rega,* 1928,
charcoal and ink on paper, private collection

colourful spaces continued to get through. The seascape gave Feininger a
new motif that took on a central role in his entire further artistic work.

'I SEE COLOURS HERE BY THE SEA, INDESCRIBABLE'[12]

On 27 June 1924 Feininger visited, for the first time, the small Pomeranian
fishing village of Deep where the Reiver Rega flows into the Baltic; the
following day he immediately started familiarizing himself with the new
surroundings by making nature-notes. He euphorically wrote to his wife
about what he had seen: 'The western sky was green and yellow and mar-
vellously luminous after the violent thunderstorm […] – and the sea, as we
came over the dunes, was golden, only more copper in colour than the sky,
which was greenish.'[13]

For a period of eleven years the remote village of Deep became an annual
place of refuge and source of inspiration for Feininger during the weeks
that he visited. This is also where he produced not just hundreds of
nature-notes but also many pen-and-ink drawings as well as watercolours,
while he reserved the work of transforming his artistic spoils into paint-

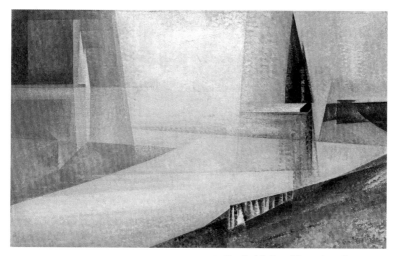

21 *Mouth of the Rega III*, 1929/30, oil on canvas,
Hamburger Kunsthalle, permanent loan from SHK

ings for when he was in his Bauhaus studio in Dessau. Feininger almost
always developed his pictorial composition in line with the same principle.
At the start of this developmental process was the nature-note; it formed
the starting point for a development of the motif into a black-and-white
charcoal drawing, which determined the light-and-dark contrasts of the
composition. The next step was the application of the colours, which
completed the painting and were often listed in detail by Feininger in the
initial sketches. The watercolours on the other hand were completely
stand-alone works, falling between the nature-notes and the paintings as
an artistic genre.

Feininger's initial disappointment that ships only passed Deep at a dis-
tance once again led to a change in his art. The pictorial space now opened
up even more, the viewer's gaze was taken wider, and the dunes and sailing
boats alike merged wholly with the charged atmosphere. Again and again
Feininger painted the same motif in different moods and colours, without
changing his perspective. His experience of nature in Deep, the wide-open
character of the landscape and the complexity of the perceived colours led
to a transparency that had not been seen before in paintings or in water-
colours, making these works a high point in Feininger's œuvre. Now, in

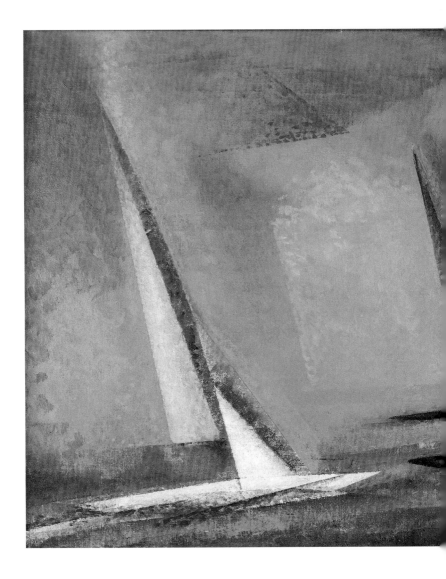

22 *Skerry Cruiser*, 1930,
oil on canvas, private collection, northern Germany

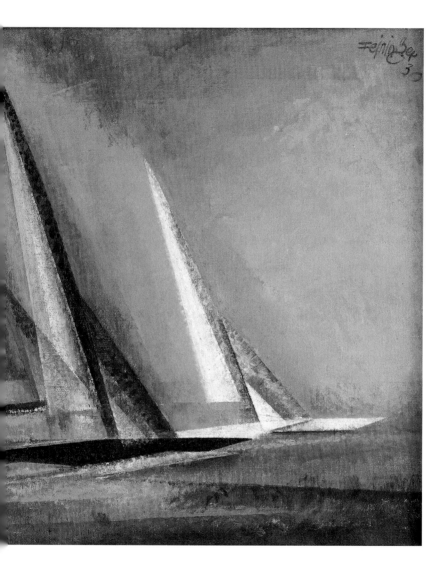

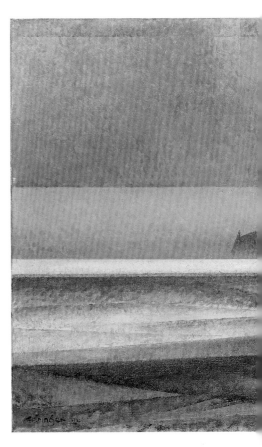

23 *Baltic Schooner*, 1924, oil on canvas,
private collection, northern Germany

1931, for his sixtieth birthday, the Nationalgalerie in Berlin put on a comprehensive retrospective of his works, cementing Feininger's reputation as one of the most important artists of Modernism in Germany.

'WHAT I REALLY MISS IS PAINTING FROM NATURE'

When the Nazis came to power in 1933 the situation became difficult for Feininger. The Bauhaus had already been closed the previous year. He was still able to rely on his gallery owners and collectors, and Deep also remained a destination and source of artistic inspiration. The invitation to

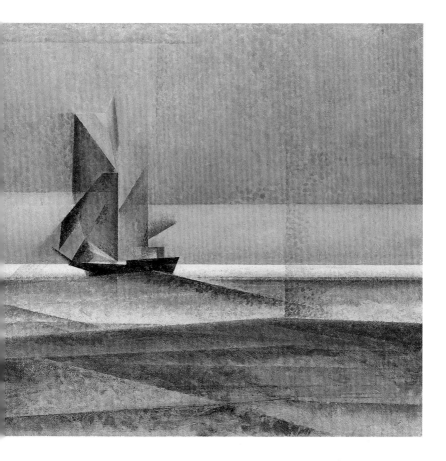

run a summer course at Mills College in Oakland in 1936 brought Feininger and his Jewish wife back to his home country for the first time in 49 years. When this invitation was issued once more the following year he decided to leave Germany for good and move to New York. He did this just a few weeks before Feininger's works fell victim to the 'Degenerate Art' campaign that took place in German museums in July 1937. He wrote the following to his son T. Lux on 31 May: 'I feel 25 years younger since knowing that I'm heading to a country where imagination in art and abstraction are not seen as absolute crimes as they are here.'[14]

Feininger's situation upon his return to New York was comparatively good. He spoke his mother tongue, met up with friends of his youth and émigrés

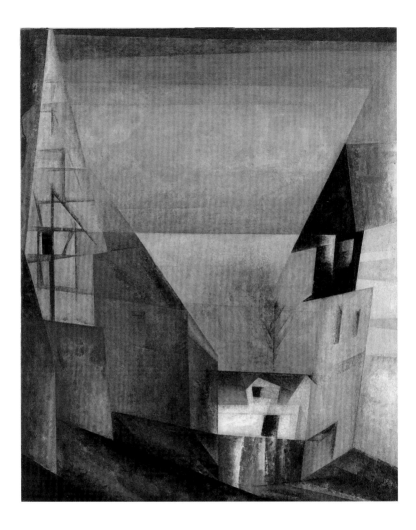

24 *Vollersroda, Spring,* 1936,
oil on canvas, Hamburger Kunsthalle,
permanent loan from a private collection

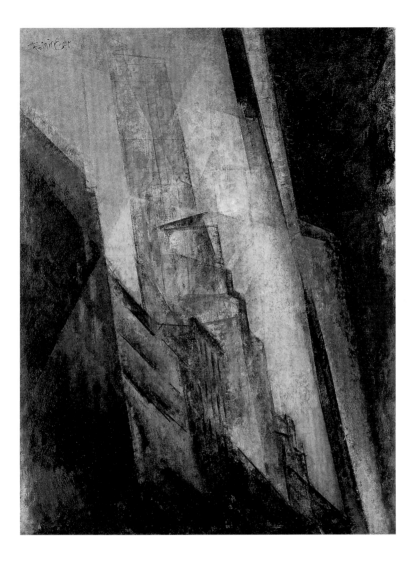

25 *Manhattan II*, 1940,
oil on canvas,
Modern Art Museum, Fort Worth

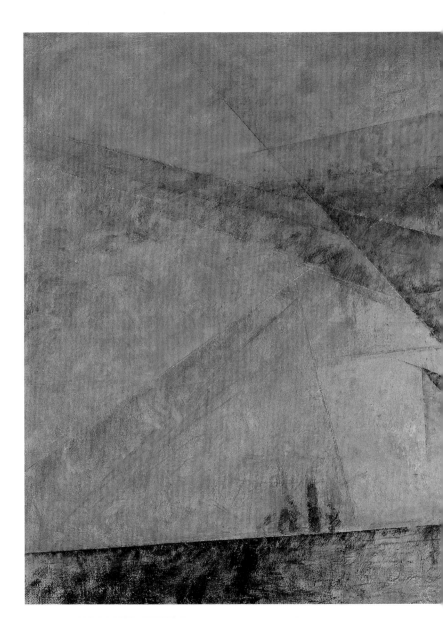

26 *Fenris Wolf,* 1954,
oil on canvas, private collection

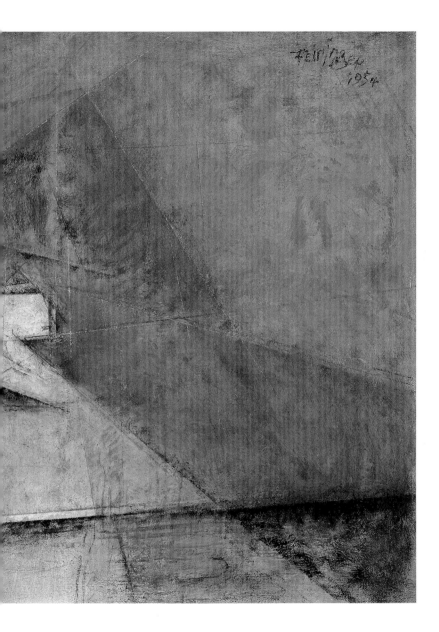

27 *The Cutting*, 1949,
oil on canvas, private collection

from the Bauhaus; he was able to rekindle old contacts from Berlin's art trade who had also fled Germany. His artistic situation was a different one, however. He had to leave behind the foundation of his creative drive, the motifs from Thuringian villages and from the Baltic; all that remained for him as inspiration were his memories and the large collection of his nature-notes. He was barely able to work as an artist for two years, and public recognition of his works only began after five years. Even a year before his death Feininger wrote to his son about his longing for Germany as an artistic source of inspiration: 'What I really miss is painting after nature and making "notes", such as on the Baltic, in Deep and in the villages around Weimar. The motifs here are somehow not enough for me, they contain too little of my inner wishes and lead to naturalistic results.'[15] Feininger struggled to find new motifs in his later works, such as the high-rise architecture of Manhattan, where he combined painted and drawn elements. Many of his paintings that he created from memory again addressed motifs from Deep and Thuringia. Forms and areas were dissolved, the reality of the environment merged with the colours and the memories became visions of the past.

28 *The Vanishing Hour*, 1951/52,
oil on canvas, private collection

ULRICH LUCKHARDT *has run the Internationale Tage Ingelheim since 2012. Before that he spent almost 25 years working at the Hamburger Kunsthalle, where he curated several exhibitions on Modernism, including Lyonel Feininger. As an author and curator of exhibitions, for example in Switzerland and Japan, he has developed an international reputation as a Feininger expert.*

1 Willi Wolfradt, *Lyonel Feininger, Junge Kunst,* vol. 47, Leipzig 1924, p. 5.
2 Letter to Julia Berg, née Lilienfeld, Berlin, 8 October 1905.
3 Letter to Alfred Kubin, Zehlendorf, Christmas Day 1912.
4 Otto Eysler in a letter to Lyonel Feininger, Berlin, 20 August 1907.
5 Letter to Otto Eysler, Weimar, 19 January 1924.
6 Letter to Julia Berg, née Lilienfeld, Berlin, 11 October 1905.
7 Letter to Julia Berg, née Lilienfeld, Baabe, 2 September 1907.
8 Letter to Alfred Kubin (as footnote 3).
9 Letter to Julia Berg, née Lilienfeld, Baabe, 29 August 1907.
10 Wolfradt 1924 (as footnote 1), p. 10.
11 Letter to Julia Feininger, Timmendorf, 7 September 1922.
12 Letter to Julia Feininger, Deep, 7 July 1924.
13 Letter to Julia Feininger, Deep, 28 June 1924.
14 Letter to T. Lux Feininger, Berlin, 31 May 1937.
15 Letter to T. Lux Feininger, New York, 6 October 1953.

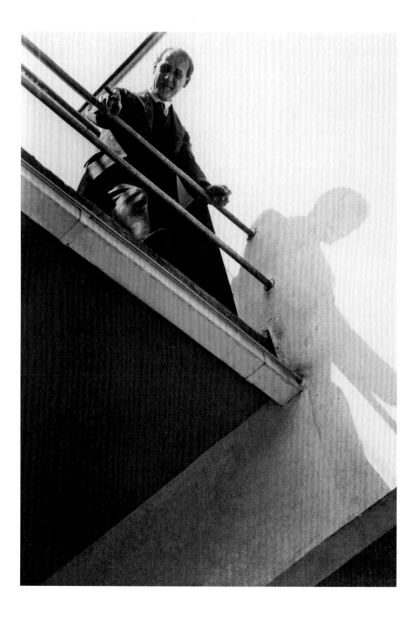

29 Lyonel Feininger on the balcony of the 'Meisterhaus', Dessau, around 1930

BIOGRAPHY

Lyonel Feininger
1871 – 1956

1871 Léonell (Lyonel) Feininger is born in New York on 17 July. His father Karl (Charles) Feininger's family originally came from Durlach in Baden (Germany) and emigrated to the United States in 1848. His father is a violinist, his mother Elizabeth Cecilia, née Lutz, a singer. Lyonel grows up with his two younger sisters Helene and Elsa in New York and with friends in Connecticut, since his parents are often on concert tours in Europe. At age eight his father starts teaching him the violin.

1887 Feininger travels to Germany in October. He gets his parents' permission to study drawing at the Allgemeine Gewerbeschule in Hamburg instead of receiving violin training in Leipzig as planned.

1888 He moves to Berlin and after passing the entry exam to the Königliche Akademie he attends the drawing class taught by Ernst Hancke.

1890/91 Some initial caricatures are published in *Humoristische Blätter*. At his father's behest Feininger attends the Jesuit Collège Saint-Servais in Liège. He returns to Berlin in the summer of 1891 and studies at Adolf Schlabitz's private drawing school. After its closure he resumes his studies at the academy.

1892–1896 Feininger leaves the Königliche Akademie in Berlin. He spends the summer in Seedorf on the island of Rügen. He regularly travels to the island until 1907. He goes to Paris in November and studies in Filippo Colarossi's studio until May 1893. He subsequently works as a caricaturist in Germany until 1910, producing works for *Ulk, Lustige Blätter, Das Narrenschiff* and *Berliner Illustrirte Zeitung* as well as for *Harper's Round Table* in New York, to name but a few.

1901/02 He marries Clara, the daughter of the painter Gustav Fürst. Their daughter Lore is born that same year and their daughter Marianne the following year. Feininger's first participation in the exhibitions of the Berlin Secession (graphic arts).

1905 Feininger meets Julia Berg, née Lilienfeld, and leaves Clara. He grows estranged from caricature, which has become work he is forced to do but does not like. Drawings are published in *Der liebe Augustin*.

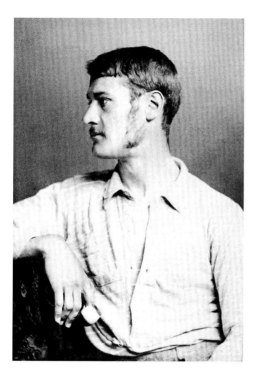

30 Lyonel Feininger, Berlin 1892

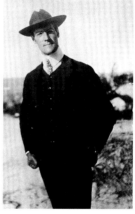

31 In Graal on the Baltic, 1905

32 Lyonel Feininger, 1896

1906 He visits Julia in Weimar, who is studying at the Grossherzoglich-Sächsische Kunstschule there. She introduces him to the techniques of lithography and etching. On 15 July he discovers the church of Gelmeroda as a motif. Feininger signs a contract with the *Chicago Sunday Tribune* for the provision of two comic strips, *The Kin-der-Kids* and *Wee Willie Winkie's World*. He is presented to the American readership as 'the famous German artist'.

At the end of July he travels with Julia to Paris, where he once again studies with Colarossi. The contract with Chicago is terminated at the end of the year; Feininger produces drawings for the magazine *Le Témoin*. He meets German artists in the Café du Dôme in Paris. He meets Robert Delaunay and forges friendships with – among others – Jules Pascin, Rudolf Levy and Rudolf Grossmann. His son Andreas is born during his stay in Paris.

1907/08 He produces some initial paintings in Paris and on Rügen. Julia and Lyonel marry in London in autumn 1908 and move to Königsstr. 32 in Berlin-Zehlendorf.

1909 Son Laurence is born. Feininger becomes a member of the Berlin Secession. Between 1909 and 1912 he makes a number of notes on nature during various summer stays in Heringsdorf on Usedom.

1910 Son Theodore Lucas (T. Lux) is born. For the first time Feininger exhibits a painting, *Longueil, Normandie* (1909), in the Berlin Secession; he had already been exhibiting drawings there since 1901. Prints by Feininger are published in the literary magazine *Licht und Schatten* until 1913.

1911/12 Feininger is represented in the exhibition *Salon des Artistes Indépendants* in Paris with six paintings. It is there that he meets Henri Matisse and encounters Cubism for the first time, a movement that deeply impresses him. An autobiographical text with six illustrations of paintings is published in the magazine *Les Tendances Nouvelles*. The following year he becomes friends with Alfred Kubin. He produces some initial architectural compositions.

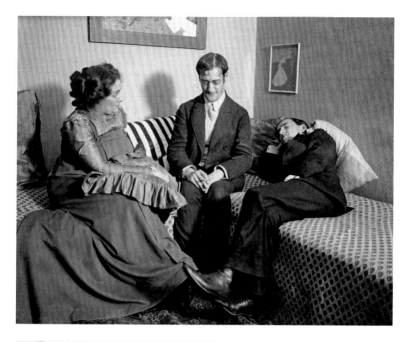

33 Julia and Lyonel Feininger
with Jules Pascin, Paris 1906

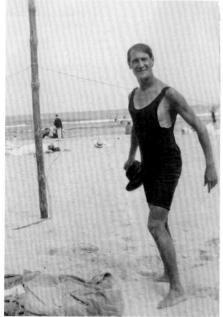

34 In Heringsdorf on Usedom,
around 1910

1913 Feininger moves into a studio in Weimar and paints the first oil painting of a series of depictions of the church in nearby Gelmeroda. Thanks to introductions by Alfred Kubin and Franz Marc he participates in the *Erster Deutscher Herbstsalon* in Berlin put on by the gallery Der Sturm. He sells some paintings for the first time, including to the Parisian fashion designer Paul Poiret, and to Berhard Köhler, a collector from Berlin. Feininger leaves the Berlin Secession in June. He designs wooden railway sets for industrial production for the Otto Löwenstein toy factory in Munich.

1914/15 Feininger draws chauvinist caricatures for *Ulk, Lustige Blätter* and *Wieland* on the occasion of the First World War. He travels to Weimar once again in spring. He meets the American painter Marsden Hartley in October 1915. He becomes friends with Karl Schmidt-Rottluff and Erich Heckel.

1916/17 He exhibits in the gallery Der Sturm in Berlin together with Conrad Felixmüller. Feininger's works are given their first solo exhibition there the following year. The first article about Feininger is written in *Kunstblatt* by Paul Westheim.

1918 Feininger becomes a member of the November Group and meets the architect Walter Gropius. He spends the summer in Braunlage in the Harz region. That is where he starts occupying himself intensively with making woodcuts; he creates approx. 117 works.

1919/20 He becomes involved in the Arbeitsrat für Kunst (Workers Council for Art). Walter Gropius summons Feininger to the Bauhaus art school, whereupon he moves to Weimar with his family. As a 'Master' he is in charge of the printing factory there and meets the sculptor Gerhard Marcks, with whom he will enjoy many years of friendship. In 1920 Feininger has his first museum exhibition in the Angermuseum in Erfurt.

1921 He travels to the Bay of Lübeck with Gropius and Vasily Kandinsky. The Detroit Institute of Arts is the first American museum to acquire one of his paintings, namely *Paddle Steamer II (1913)*. Feininger's folder *12 Holzschnitte (12 Woodcuts)* becomes the first publication released by the

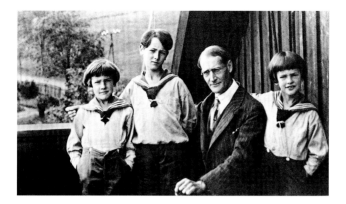

35 Lyonel Feininger with his sons Laurence,
Andreas and T. Lux (l. to r.), Braunlage 1918

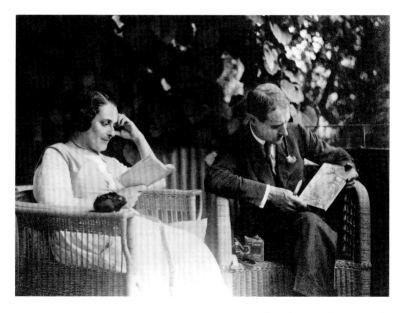

36 Julia reads to Lyonel Feininger as he
prepares a woodcut, Weimar, around 1919

Bauhaus. Between 1921 and 1928 he composes thirteen fugues for piano/organ. A joint exhibition with Alexander Archipenko is arranged in the Kunstsalon Ludwig Schames in Frankfurt in 1922.

1923 Feininger's works are exhibited in the United States for the first time in the Anderson Galleries, New York, as part of the exhibition *A Collection of Modern German Art*.

1924 On the initiative of the art dealer Galka Scheyer, Lyonel Feininger, Alexej von Jawlensky, Vasily Kandinsky and Paul Klee set up the exhibition group *The Blue Four* in order to present their works together in the United States. Feininger spends the summer in the fishing village of Deep on the Baltic, in Eastern Pomerania, a place he regularly returns to until 1935. Willi Wolfradt publishes the first monograph about Feininger as part of the *Junge Kunst* series.

1925–1927 After the Bauhaus relocates from Weimar to Dessau in 1925 Feininger moves into one of the 'master houses' in Dessau with his family. It is his request that he retain the title of 'Master' without having any teaching commitments. In 1927 he meets the founding director of the Museum of Modern Art in New York, Alfred H. Barr jr., during the latter's visit to the Bauhaus.

1929–1931 Feininger is commissioned by the city of Halle to paint a cityscape; he temporarily moves into a studio in the gate tower of the Moritzburg. He creates eleven paintings and 29 drawings of Halle by 1931. He is represented with seven works in the exhibition *Paintings by 19 Living Americans* in the Museum of Modern Art. Extensive exhibitions are organized in the Nationalgalerie in Berlin, the Folkwang Museum in Essen and in Dresden in honour of his sixtieth birthday. Feininger is considered one of the few important modern artists in Germany.

1932–1934 Under the growing political influence of the Nazi Party it is decided that the Bauhaus in Dessau be closed and that all teaching staff be dismissed. Feininger moves in with friends in Berlin in spring 1933; the following year he moves to Berlin-Siemensstadt.

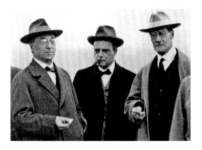

37 Vasily Kandinsky, Paul Klee and
Lyonel Feininger (l. to r.), Dessau 1926

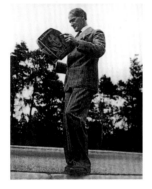

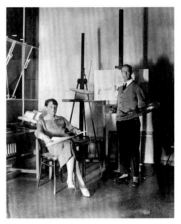

38 Feininger in Dessau (?),
around 1928

39 Julia and Lyonel Feininger in the
studio in the Bauhaus, Dessau 1927

40 Lyonel Feininger
in Dessau, 1928

1936 At the invitation of the art historian Alfred Neumeyer Feininger travels to America with Julia, where he spends the summer teaching at Mills College, Oakland, California. The first solo exhibition of his works in the United States takes place in New York's River Gallery. After the couple's return at the end of the year they decide to emigrate to the US.

1937 The Feiningers leave Germany on 11 June. Their sons have already moved to Stockholm, Italy and New York. Feininger once again teaches at Mills College in Oakland. Around 400 of his works are confiscated by the Nazis from museums in Germany; some of them are put on display in the 'Degenerate Art' exhibition. In New York the Feiningers initially reside in the Hotel Earle on Washington Square; they move to 235 East 22nd Street the following year. Feininger spends the summers in Falls Village, Connecticut and from 1945 onwards in Stockbridge, Massachusetts, among other places.

1938/39 He designs large murals for the Marine Transportation Building and the Masterpieces of Art Building for the World's Fair in New York in 1939. However, he is not allowed to execute them on the building himself since he is not a union member. On 19 November 1939 he creates his first painting in the United States. He participates in the exhibition *Art in Our Time* in the Museum of Modern Art in New York and in the *Pittsburgh International Exhibition*.

1940/41 He paints the first *Manhattan* paintings. Lyonel Feininger starts working with the Curt Valentin Gallery in New York in 1941.

1942 Feininger participates in the exhibition *Artists for Victory* in the Metropolitan Museum of Art, New York and wins the 'acquisition' prize for *Gelmeroda XIII* (1936).

1944 In the first major retrospective in the Museum of Modern Art in New York, which takes place alongside a memorial exhibition for Marsden Hartley, 75 of his paintings are displayed, including 26 that he produced in the United States. He becomes friends with the painter Mark Tobey and meets the French artist Fernand Léger.

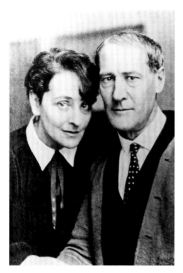

41 Julia and Lyonel Feininger, 1929

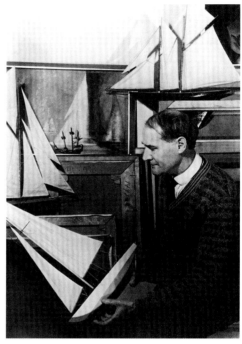

42 Feininger with model
sailing boats, around 1930

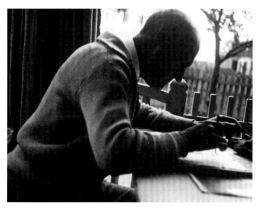

43 Feininger drawing,
Deep 1929/30

1945 Feininger gives a summer course in Black Mountain College, North Carolina and meets Walter Gropius again, who has been living in the United States since 1937.

1947/48 Feininger is elected President of the Federation of American Painters and Sculptors. He has to undergo a serious operation in New York the following year, after which he recuperates in Stockbridge.

1949/50 Feininger exhibits his works at the Institute of Contemporary Art in Boston together with Jacques Villon. He designs a mural for the passenger steamship the SS Constitution in 1950. The Kestner Gesellschaft in Hanover organizes a major exhibition with watercolours in Germany for the first time since 1931.

1951 Lyonel Feininger celebrates his 80th birthday in Gropius's home in South Lincoln, Massachusetts.

1954/55 Retrospectives are held in Munich, Hanover and Amsterdam. He creates his final painting, *Evening Haze*, the following year.

1956 Lyonel Feininger dies in his flat in New York on 13 January. He is buried at Mount Hope Cemetery in Hastings-on-Hudson, New York.

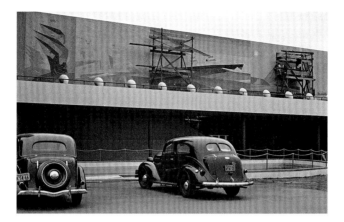

44 Mural on the Marine Transportation Building, World's Fair, New York 1939

45 Lyonel Feininger, Dessau, around 1930

46 Lyonel Feininger, New York, 1946

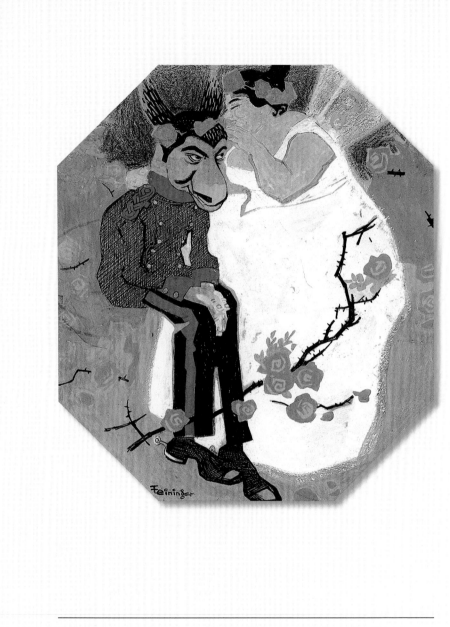

A Midsummer Night's Dream Destroyed (Draga and Alexander of Serbia), 1901, ink, gouache on paper, private collection, published in: *Lustige Blätter*, XVI, 1901, no. 24, cover

ARCHIVE

Finds, Letters, Documents
1901–1939

I

After Lyonel Feininger met his future partner Julia Berg in the summer of 1905, he developed doubts about his successful work as a caricaturist. It was his desire to develop his art freely and independently from publishers that turned his work as a commercial graphic artist increasingly into forced labour. On 5 November 1905 he wrote to Julia: 'God forgive me the bad picture [...] there is so much within me. Be sad with me that I must earn my money in this way, instead of by chopping wood or some other honest trade that would not disgrace the talents of a man.' On 18 August 1909 he mused: '[...] at the bottom of my soul I'm not a comic-paper artist.' His emancipation away from caricature was not always met with understanding – his client Dr Otto Eysler, the publisher of Lustige Blätter, *being a case in point. On 20 August 1907 he expressed his displeasure:*

'Once again months have passed during which we haven't been able to show any of your pictures. [...] We have always viewed your drawings as ornaments and valuable additions to our publication. However, the general consensus unfortunately is that you have developed a certain grotesque and highly exaggerated tone that is incomprehensible to the German readership. [...] Your strength lies not in mere distortion but in comic design and composition and it is our sincere desire to present you again to our readers in this genre that is so very much your own.'

A commission by the Chicago Sunday Tribute for two comic strips – The Kin-der-Kids *and* Wee Willie Winkie's World *– proved crucial for his career as an independent artist. They gave Feininger the financial independence he longed for. On Christmas Day 1912 he described his breakthrough in a letter to Alfred Kubin:*

'My career has been very strange: I spent almost fifteen years working as an illustrator, involuntarily, in order to get by, and despite the fact that I always had to torture myself in order to meet the publishers' wishes, to

I *The Kin-der-Kids, Feininger the Famous German Artist Exhibiting the Characters He Will Create*, 1910, published in: *Chicago Sunday Tribune*, 29 April 1906 *Blätter*, XVI, 1901, no. 24, cover

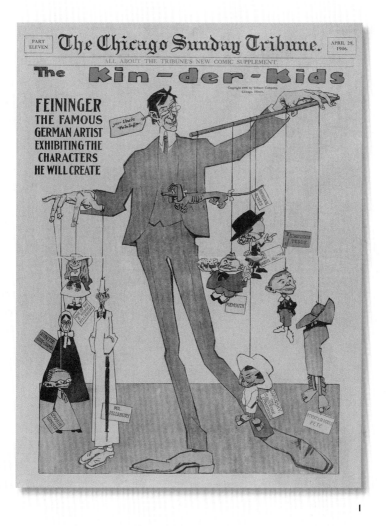

some extent I managed to develop quite a good "reputation" – six to eight years ago. Then came the liberation! A contract with Chicago, which allowed me to move to Paris and finally get to experience the world of art. It was the first time I was able to think and feel and work for myself. It has only been in the past five years that I have learned what art could and had to be for me!'

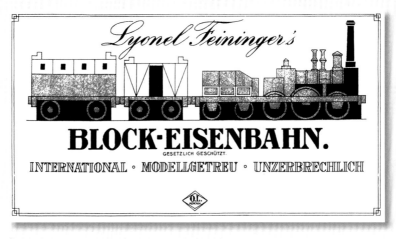

2a

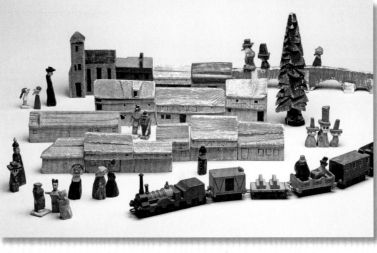

2b

2a Label for the *Block-Eisenbahn* (wooden train), 1914
2b Buildings, figures, a bridge and a tree as well as the model
railway with a tender and four waggons, 1913 and later, painted wood,
private collections

2

In spring 1913 Feininger started designing trains, locomotives and carriages made of painted wood for the Otto Löwenstein toy factory in Munich. After a fair number of designs on paper, the production of prototypes and (presumably) the manufacture of a small series, this project, into which Feininger had put high hopes, came to a sudden end when World War I broke out. He wrote euphorically to Julia on 7 April 1913:

'But do you know what gives me the most hope? That the trains are apparently very popular (heaven forbid I've got false hopes about this!), and therefore represent something new, I will build new and old models […] I will even create some very, very old trains from the 30s. These items will be a hit, this will definitely be great business! And then we'll see! I'll surely become ten years younger when I'm earning money again, especially when doing so without prostituting my art.'

After the failure of the train project Feininger started in 1915 to saw small houses and figures out of wood and paint them for his three sons: 'My usual preparatory period for Christmas when I do my woodworking is about to begin […]. The boys are expecting with certainty that I will make some little men for them.' What was initially intended as a toy town for them steadily developed into a larger 'town at the end of the world' that picked up on motifs from Feininger's work as a visual artist, for example the town hall in Swinemünde, the church in Gelmeroda and the city gate of Ribnitz. These items soon became sought-after objects that Feininger gave to the children of his Bauhaus friends as well as to students.

3

Even before the official start of his teaching position at the Bauhaus in Weimar in the autumn of 1919 Feininger exhibited a large number of his nature-notes there in order to present to the students his own artistic development. While Vasily Kandinsky and Paul Klee were developing theories of art teaching, Feininger always focused primarily on the individual development of his students. In a letter dated 27 June 1919 he wrote to his wife Julia:

'The exhibition of prints has been in place since yesterday afternoon and has turned out quite presentably. I spent three days, from eight in the

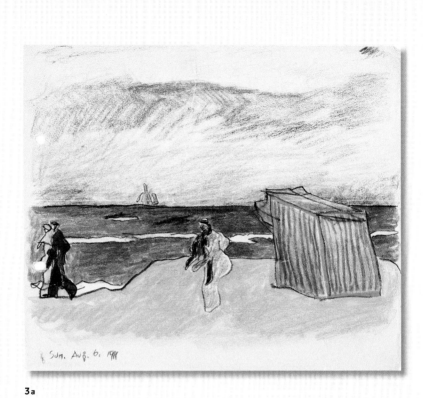

Sun. Aug. 6, 1911

3a

morning until nine in the evening, on my feet to remove engravings and photographs after the old masters from the large frames that usually adorn the hallways of the Bauhaus. [...] To select just the good ones among several thousand sketches and to then make the right selection and compilation, frame by frame! I have around ten large frames, including some measuring more than 125 cm in width, arranged chronologically with

3a Nature-note *untitled (figures on the beach)*, Heringsdorf 1911, coloured chalks, Harvard Art Museums/Busch-Reisinger Museum, Cambridge MA
3b Nature-note *untitled (four figures)*, Paris 1908, coloured chalks, Harvard Art Museums/Busch-Reisinger Museum, Cambridge MA

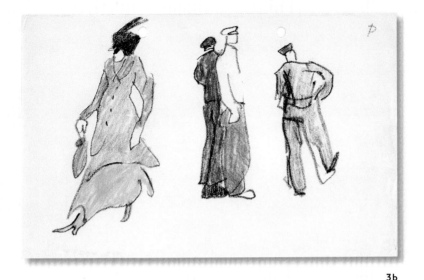

drawings of nature – I have already seen how good this idea was for the students. Starting with Quiberville and Paris, 1906 – then 07, 08–09, [...] then 1911, the refined items, transitions to Cubism – 1912 already more deliberate and less impressionistic – 13 – 14 Weimar, already quite taut and cubic – and finally two frames of Braunlage 1917. The students can see from this what was necessary in order to take this path – and how you can study without drawing in class. Gropius, this dear man – I'm telling you here that I dearly love and venerate this person – was so thrilled by it that he squeezed my hand quite impulsively.'

4

When, in June 1924, Feininger first visited the fishing village of Deep, where the Rega flows into the Baltic, his art changed. The wide open space and the atmosphere he found there allowed him to express a pictorial space full of transparency and light in his artistic production had not existed beforehand. Observing natural phenomena became a central theme for Feininger even more so than his sketches. On 7 July he captured his impressions in a letter to Julia:

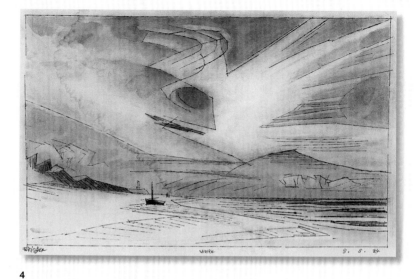

4

'Towards the evening on the beach all was flat as a millpond and there was a curious cloud formation. The colours I see here by the sea are indescribable. Sunsets like I haven't seen since childhood. Two days ago it contained all the colours of the rainbow, in outrageous purity, a very threatening sky that was heralding yesterday's thunderstorms! Last night I suddenly experienced my cloud, […] in exactly those colours! It's always the case, I can paint what I want – it's confirmed by nature itself, the transcendental formation of space in the picture makes it possible to have an impression of that which was experienced that is equivalent. I currently don't get round to composing, I'm in a period of reception and I'm focused wholly on that. Once I am removed and in a different location, the re-experiencing then comes to me in the only possible form of recreation: that of the picture.'

4 *Cloud*, 1924, ink, watercolour on paper, Harvard Art Museums/ Busch-Reisinger Museum, Cambridge MA

In September 1937 Lyonel and Julia Feininger left California and arrived in New York, where they continued to live until their deaths. They initially lived in the Hotel Earle on Washington Square, since their newly built flat on 235 East 22nd Street was not ready. By 24 September at the latest Feininger started drawing small nature-notes depicting the view from the hotel room. Even though he turned some of these sketches into drawings, a new artistic beginning in New York was out of the question.

Julia Feininger's diary, unpublished to date, gives us an insight into how Feininger was at least financially secure thanks to the murals for the World's Fair in 1939. On 3 March 1938 Feininger signed the contract for an initial mural on the exterior façade of the Marine Transportation Building, a contract which he had managed to get through the good offices of Wilhelm Valentiner, who, in his capacity as museum director in Detroit, had once before – in 1921 – acquired a painting by Feininger for the collection. Just five days after the commission was issued some initial designs were approved, which Feininger then completed on 26 May. The following day Julia wrote in her diary: '365 days since Leo has done any work of his own – today he delivered the mural, significant.'

The result was so convincing that further commissions followed. 'Leo's painting!!' Julia wrote jubilantly on 2 January 1939 and reported on 28 January: 'an exciting plan for a very large mural, if that were to work out! It would mean untold things for us.' On 8 March came an end to that hope: 'Valentiner said on the phone that it was as good as ruled out that he would be able to get the mural passed – this constant waiting wears me down.' Nevertheless life went back to normal for the Feiningers; Julia commented on 12 March that an old habit from Germany had made a comeback: 'First time in America that I read to him while painting,' namely Abenteuer in der Sylvesternacht *by E. T. A. Hoffmann.*

However, there was progress with the second mural, painting the entire courtyard of the Masterpieces of Art Building – 'Mural almost secured.' On 1 April the good news finally arrived: 'Valentiner called – mural has been secured thanks to the donation of the necessary sum by Edsel Ford's sister, Mrs Kautsler from Detroit. This is a great fortune for us – but a completely ridiculous business.' The commissions for the murals at the World's Fair in New York in 1939 were not just an economic necessity for Feininger. They also enabled him for the first time to work freely in the city of his youth.

SOURCES

—

PICTURE CREDITS

The material for the illustrations was kindly made available to us by the museums and collections cited in the captions, or they were taken from the publisher's archive or from: (the figures refer to page numbers)

· akg-images: 8, 15, 26/27, 41
· Josef Albers: 59 centre
· Artothek: 23, 30/31
· bpk: 19
· Bridgeman Images: 64 bottom
· Christie's Images Ltd 2015: 38/39
· Andreas Feininger: 55 bottom, 59 bottom
· Julia Feininger: 49 centre, 53 top
· T. Lux Feininger: 55 centre left, 57 bottom
· Fotostudio Bartsch, Karen Bartsch, Berlin: 32/33
· Hamburger Kunsthalle: 35, 40
· President and Fellows of Harvard College: 59 top, 66, 67
· Kunstsammlungen Chemnitz: 24, 25
· Lucia od. László Moholy-Nagy: 46
· Philadelphia Museum of Art: 22
· Scala Group: 18
· The Art Institute of Chicago: 17 top

Unless otherwise stated the images in the biography are from the estate of T. Lux Feininger, as is the label for the *Block-Eisenbahn* p. 64 top

—

LYONEL FEININGER'S LETTERS FROM WHICH EXCERPTS WERE TAKEN ARE LOCATED IN THE FOLLOWING PLACES:

Letters by Lyonel Feininger to Julia Berg (later Feininger), typescript, made by Julia Feininger after 1956 (carbon copy in the archive of the Hamburger Kunsthalle); originals in Houghton Library, Harvard University, Cambridge MA

Letters by Lyonel Feininger to Alfred Kubin, 1912–1919, originals in the Lenbachhaus, Kubin Archive, Munich

Letter by Lyonel Feininger to Dr Otto Eysler, 20 August 1907, Houghton Library, Harvard University, Cambridge, MA

Letters by Lyonel Feininger to T. Lux Feininger, originals in T. Lux Feininger's estate

We have made every effort to find all copyright holders. However, should we have omitted to contact copyright holders in any individual instances, we would be most grateful if these copyright holders would inform us forthwith.

Published by
Hirmer Verlag GmbH
Bayerstraße 57–59
80335 Munich
Germany

Cover illustration: *Schärenkreuzer* (detail), 1930,
see pp. 36/37
Double page 2/3: *Fischerboote* (detail), 1921,
see p. 25
Double page 4/5: *Regamündung* (detail), 1929/30,
see p. 35

www.hirmerpublishers.com

TRANSLATION FROM THE GERMAN
Josephine Cordero Sapien, Exeter
–
COPY-EDITING/PROOFREADING
Michael Scuffil, Leverkusen
–
PROJECT MANAGEMENT
Rainer Arnold
–
DESIGN/TYPESETTING
Marion Blomeyer, Rainald Schwarz, Munich
–
PRE-PRESS/REPRO
Reproline mediateam GmbH, Munich
–
PAPER
LuxoArt samt new
–
PRINTING AND BINDING
Passavia Druckservice GmbH & Co. KG, Passau

Bibliographic information published by the
Deutsche Nationalbibliothek
The Deutsche Nationalbibliothek lists this
publication in the Deutsche Nationalbibliografie;
detailed bibliographic data are available on the
Internet at http://dnb.dnb.de.

ISBN 978-3-7774-2974-8

Printed in Germany

THE GREAT MASTERS OF ART SERIES

ALREADY PUBLISHED

WILLEM DE KOONING 978-3-7774-3073-7	**HENRI MATISSE** 978-3-7774-2848-2
LYONEL FEININGER 978-3-7774-2974-8	**KOLOMAN MOSER** 978-3-7774-3072-0
PAUL GAUGUIN 978-3-7774-2854-3	**EMIL NOLDE** 978-3-7774-2774-4
RICHARD GERSTL 978-3-7774-2622-8	**PABLO PICASSO** 978-3-7774-2757-7
JOHANNES ITTEN 978-3-7774-3172-7	**EGON SCHIELE** 978-3-7774-2852-9
VASILY KANDINSKY 978-3-7774-2759-1	**VINCENT VAN GOGH** 978-3-7774-2758-4
ERNST LUDWIG KIRCHNER 978-3-7774-2958-8	**MARIANNE VON WEREFKIN** 978-3-7774-3306-6

www.hirmerpublishers.com